Happy Birthday, Charlotte!

With love from

Mom

XXX

November 1996.

COUNTRY LIFE

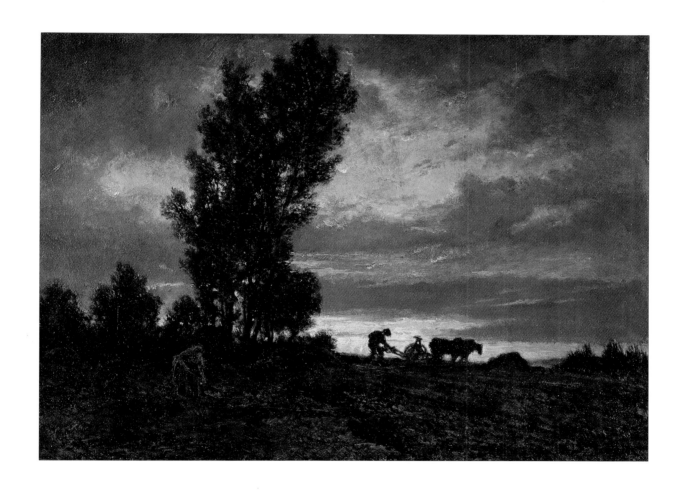

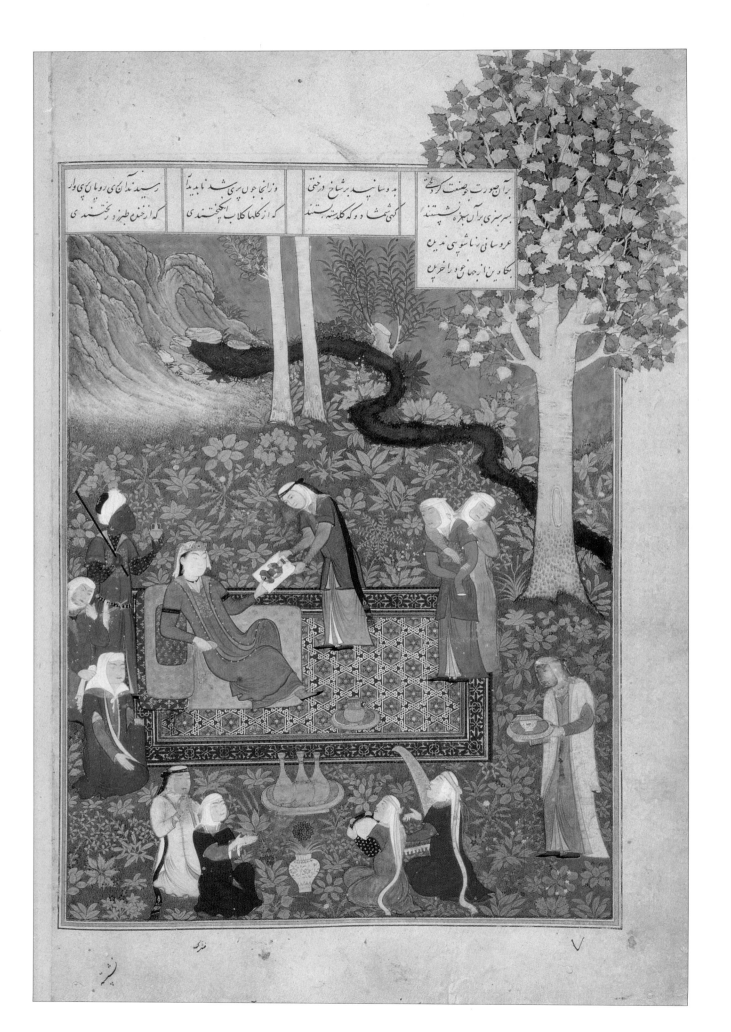

CELEBRATIONS IN ART

COUNTRY LIFE

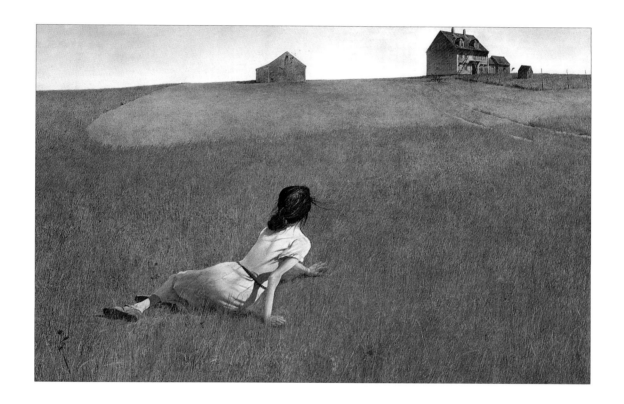

ALEXANDRA BONFANTE-WARREN

MAGNA BOOKS

A FRIEDMAN GROUP BOOK

This edition published in 1995 by
Magna Books
Magna Road
Wigston
Leicester LE18 4ZH
UK

ISBN 1-85422-949-4

CELEBRATIONS IN ART: COUNTRY LIFE
was prepared and produced by
Michael Friedman Publishing Group, Inc.
15 West 26th Street
New York, New York 10010

Editor: Sharyn Rosart
Production Editor: Loretta Mowat
Art Director: Jeff Batzli
Designers: Lynne Yeamans & Lori Thorn
Photography Editor: Jennifer Crowe McMichael

Printed in China by Leefung-Asco Printers Ltd.

Additional Photography Credits: Page 1: Pierre-Étienne-Théodore Rousseau, *Landscape with a Plowman*, c. 1848. Oil on panel, 15" × 20" (38 × 51.5cm). The Hermitage, Saint Petersburg. Scala/Art Resource, New York. Page 2: Unknown, *Timurid Miniature*, c. 1340. By permission of the British Library, London. Page 3: Andrew Wyeth, *Christina's World*, 1948. Tempera on gessoed panel, 32¼" × 47¼" (81.9 × 121.3cm). The Museum of Modern Art, New York. Page 5: Jacob Lawrence, *The Migration of the Negro*, (a series of sixty works), Panel No. 9: "They left because the boll weevil had ravaged the cotton crop." 1940–1941. Tempera on hardboard, 12" × 18" (30 × 45cm). The Phillips Collection, Washington, D.C. (odd numbers).

INTRODUCTION

Elemental, mysterious, nourishing, pure, restful, dangerous, sublime—over time, people have attributed to the natural landscape all of these qualities—and more. The countryside, and life in the country, continues to excite powerful emotions, even in this day of urban and suburban expansion. It is no wonder that artists have been inspired to create some of their most evocative and transcendent works by both the idea and the experience of the country. *Country Life* has collected thirty-five visions of the country from artists both ancient and modern—a small but thought-provoking selection from the vast oeuvre of works inspired by nature's majesty.

The profound power of the country comes from its duality: it is at once Mother Earth, the provider; and also, nature untamed, the destroyer. We depend utterly on, and are at the mercy of, chance and weather, the vagaries of winds. The closer to the land we live, the more obvious this truth. In an effort to exercise some control over the uncontrollable, wise thinkers of every period have suggested careful tending of the earth. The conscientious care of the land, the effects of a prudent hand, were considered worthy of being portrayed, as in Ambrogio Lorenzetti's mural *Good Government in the Country* (1338–40), or the Limbourg Brothers' *February* in the Duc de Berry's *Très Riches Heures* (c. 1485). Yet even the most careful husbanders always discover that good management goes only so far; it cannot entirely harness the mystery that is nature, unpredictable, dangerous, and beyond even prayer's power to tame. Another approach to placating nature's forces requires sacrificing some *thing* of value, besides our toil, for the sake of life itself. In the earliest societies, humans worshipped nature itself, attempting to propitiate, coax, and bribe the unknowable forces that can deliver astonishing abundance or cast desolation upon the land. The very word "pagan" comes from the Latin *paganus,* "country

dweller." Titian's *Bacchanal* (c. 1518) shows the pagan world receding with the coming of Christianity—but traces of nature's powerful hold on us remain…next to and among the tilled, tidy fields lie the thickly wooded forests—ancient places of power, where shadows lurk and mystery rules. Painted more than four hundred years later than Titian's *Bacchanal*, Horace Pippin's evocative *Night Call* (c.1940) recreates that same sense of magic as it captures the primal lonely essence of a woods.

~

The history of the city is also a history of the country: the urban entity that almost everywhere in the world now over-shadows its rural counterpart first emerged as a marketplace, a crossroads for the exchange of goods, ideas, and people from the country—which was, before then, all that there was.

Since the first city developed, artists have portrayed the country as its opposite, an ideal place where the harried city-dweller could be soothed and find respite from the demands of busyness, external or internal.

The classical Greek poets, their cities entwined in endless strife, spoke wistfully of Arcadia, the place of lost peace, already receding into legend. This carried over into sprawling Rome, and Pompeii, the city's town away from town. There, on the walls of Livia's villa, painted trees, birds, and fruit became the visual counterpart of Virgil's pastoral writings. The real Arcadia was a region that, unable to unite politically, was contested down the centuries—probably because it was *too* country, with no city powerful enough to give it identity.

Every culture has idealized the countryside in its own way. For Christians, the Garden of Eden symbolized the first rural landscape looked back upon with longing, which may explain the enduring vision of the country as a source of innocence. For many, the country was (and is) seen not only as more restful but also as morally superior to the city. Giovanni Bellini's *Saint Francis in Ecstasy* (c. 1485) and Giorgione's *The Tempest* (c. 1505) both emphasize the contrast between the spiritual authenticity of the countryside and the worldliness of the city.

Almost as frequently as city dwellers have romanticized the country have they patronized its dwellers, calling up familiar stereotypes such as country mice, hicks, and rubes, all dupes of the city sophisticates. Alternatively, the urban establishment sometimes feared the effects of country life, imagining that the rural inhabitants, cut off from the enlightened atmosphere of court and city, might lose all moral virtue and go to seed. Pieter Brueghel the Elder's *Peasant Wedding* (c. 1565) reveals a sardonic view of human nature. In that work, he shows us a less idealized scene of the picturesque peasants. Fat and fulsome, they celebrate the nuptials that the dullard takes to mean all's well on the farm, while the more sophisticated viewer sighs, seeing only the faceless rites of fertility. More typically, the peasants in Louis Le Nain's *Peasant Family* (1640), are shown uncomplaining, content with their lot.

During and after the Renaissance, European artists who depicted country life did so often at the behest of noble patrons, who sought in these images not only portaits of natural beauty, but also confirmation of their own social status. In the city, a landed patron who missed the rich colors and regular rhythms of the seasons on an aristocratic estate might seek out a painting of such pastoral loveliness. The sons and daughters of privilege purchased pictures of the land that awaited their leisure, and also endowed them with responsibility, wealth, and indeed, their very names and places in society. Their pride sprang from the land for which their families provided a splendid procession of caretakers. Thomas Gainsborough captured this meaning for *Robert Andrews and His Wife* (c. 1749), as Angelica Kauffmann did for a Spanish-born King of Naples, in *The Family of Ferdinand IV* (c. 1782–1784). Peter Paul Rubens painted his own accession to the landed class in *Landscape with the Château of Steen* (1636).

As the Industrial Revolution changed the face of the countryside forever, the old order slipped away. The middle class emerged, disrupting the previously smooth functioning of society. Peasant became farmer, neither serf nor master. As the decreed organization of society began to fail, the milkmaid's daughter, once sure to follow in her mother's wake,

faced uncertainty—as did the landed classes themselves. And so, in the naturalistic style popular during the nineteenth century, Theodore Rousseau's *Landscape with a Plowman* (c. 1848) and Rosa Bonheur's *Plowing in the Nivernais* (1849) show, in their attention to such details as the curve of a back, the painters' awareness that momentous changes were underway, and nothing would be again as it had always been.

In modern times, wealthy city denizens have come to regard the country as a playground—Claude Monet took an urban public to the countryside in *On the Seine at Bennecourt* (1868). On weekends, country house parties recreated a distant echo of the ripe revels of myth. Refreshed, the city folk write, paint, doze, walk, and rediscover the garden.

～

In the twentieth century, land has come to represent not mystery or fertility but commerce. On this land there is no heirarchy of farmers, shepherds, goatherds, cowhands, milkmaids, pickers, balers, or gleaners. Large landowners reign alone over their sprawling empires, surrounded and supported by the invisible, transient many, immortalized by Cândido Portinari in *Café* (1935).

Love of the land, when described by those who work it, is often heartfelt and rarely unmixed. The labor is back-breaking, the results miraculous. Perhaps it is that bittersweetness that lifts the worker from drudgery—sunup to sun-down—to dignity. William H. Johnson's *Early Morning Work* (c. 1940) manages to combine the two in a sunny icon of the joy of family and work.

～

Despite enormous changes in the way we view and utilize the land, its profound influence on us remains constant. The artists whose inspiration and subject is the countryside have chronicled our responses to the land over time, mapping our inner landscapes of emotion and thought as surely as they have represented the scenic outer vistas…in luscious oil, sinuous ink, and gleaming tempera, the paintings in this volume tell a wordless tale as old as the earth itself.

UNKNOWN

Garden Scene, Villa of Livia

1st century A.D.

FRESCO FROM THE WALL OF THE VILLA LIVIA. MUSEO NAZIONALE ROMANO DELLE TERME, ROME.

This trompe l'oeil fresco, with the conceit of a tiny wall circling an imaginary tree, conveys the elegant sophistication of Livia Drusilla (c. 55 B.C.–A.D. 29), who was the wife of Octavian Augustus, the first emperor of Rome, and the mother of the Emperor Tiberius. In practical, decorative terms, the perspective of the painting makes the room seem larger; the colors, painted into wet plaster, are still vigorous. The scene, with its fruits, flowers, birds, and the suggestion of a wind blowing, is enchanting and utterly artificial, far from the businesslike reality of Livia's well-managed country estates. Just as the cage emphasizes the freedom of the birds, the chaos of genuine nature is here transmuted into the overgrown lushness of a vacant lot—a riot of life that refreshes the eye and the imagination—without the inconveniences of the real outdoors.

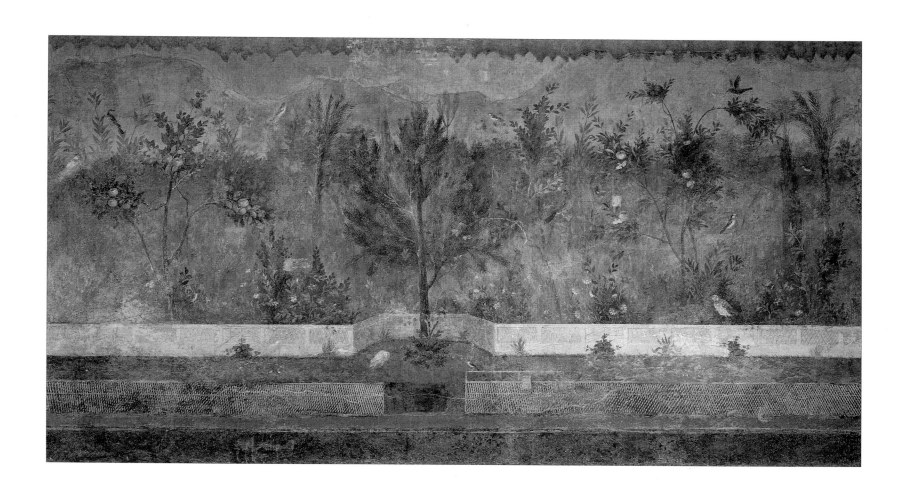

UNKNOWN

A Clear Day in the Valley

c. 12th–13th century

HAND SCROLL: INK AND LIGHT COLOR ON PAPER, 15" × 60⅓" (37.5 × 150.8CM).
CHINESE AND JAPANESE SPECIAL FUND, COURTESY OF MUSEUM OF FINE ARTS, BOSTON.

This work was originally attributed to the Chinese landscape master Tung Yüan, who, with Li Chêng, developed the long perspective seen here. Recently, this drawing was reattributed to an unnamed artist who painted it some two hundred years after Tung Yüan, proof that the artist of this peaceful scene scrupulously observed the tradition of reproducing the style of a master exactly. The point of view is a spot on a hillside of the valley. The river that created the valley flows lazily and benevolently in this season. There is fog elsewhere, in other gullies of these mountains, but here all is manifest and distinct, from the evergreens on the facing slopes to the deciduous trees of the valley floor. Note the tree trunks, which, though stylized, are as individual as human faces. Between two branches of the river, a house stands, open to the clear weather. There is no fear of robbers; there are no secrets. Two figures make their way home with their bundles. In their exquisite balance and contrast, the elements of this work compose not a narrative, but a poem that could be titled "A Clear Day in the Valley."

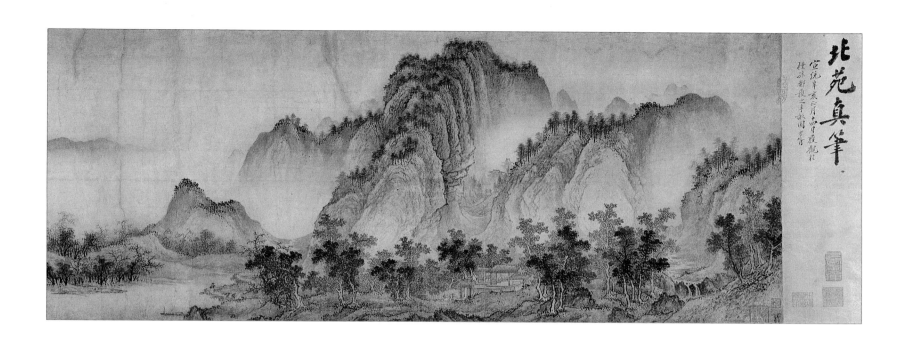

AMBROGIO LORENZETTI

Country Scene

(detail from *The Effects of Good Government*)

1338–1340

FRESCO, 46' (13.8M) WIDE. PALAZZO PUBBLICO, SIENA.

This is a detail of the edifying fresco *Allegory of Good Government: The Effects of Good Government in the City and the Country*, which was commissioned from Ambrogio Lorenzetti (c. 1290–1348) for the Palazzo Pubblico in Siena, Italy. It depicts the peace and prosperity that the government of Siena provided for its people. The Chinese quality of the landscape may reflect the influence that arrived with the active trade between Asia and Italy, but the contours of the hills belong recognizably to the area around Siena. In the foreground, a tidy tilled field speaks of the orderliness of good government, the prosperity that peace brings, and the economic self-sufficiency that was the pride of the city. The elegant walls appear to be no more than a brick thick, though good and high, implying that the city is secure but not afraid. A detail any Tuscan would have noticed is the simple rectangular shape of the merlons (solid parts of battlements) that surmount the city walls, tower, and gate, identifying the city as a partisan of the Pope against the German emperors. Nine years after this fresco was completed, the Black Death struck Europe and Asia, putting an end to a brilliant age characterized by both refinement and arrogance.

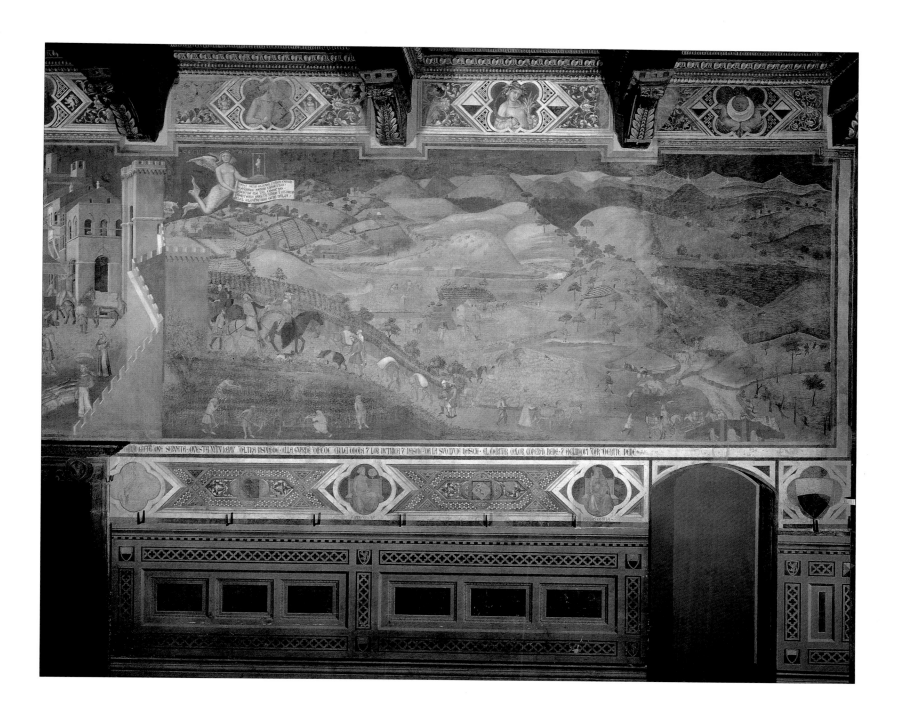

LIMBOURG BROTHERS

February

(from *Les Très Riches Heures du Duc de Berry*)

1413–1416

ILLUMINATED MANUSCRIPT PAGE. MUSÉE CONDÉ, CHANTILLY, FRANCE.

Among the precious materials used to illustrate this splendid prayer book are gold leaf and ground lapis lazuli, befitting the magnificence and pleasing the eye of the wealthy, worldly, and powerful Duc de Berry (brother of the king of France), for whom the book was created. It is easy to imagine that the duke found in the images of this unique work a spiritual affirmation of God's ubiquitous touch. In these exquisitely illustrated pages were scenes of life from the duke's prosperous estate. In *February*, industrious peasants perform their winter tasks, as busy as the bees in their hives at the center of the miniature, while the sheep huddle in their pen and the birds scratch at the hard ground. Indoors, other workers rest and warm themselves at a snug fire, the women's blue dresses perhaps handed down from the manor's ladies. The scene illustrates not only a well-ordered estate, but the divinely ordered estates: in the social order of fifteenth-century Europe, just as the woodchopper's father did the same work, so would his son, as certainly as the sign of Pisces follows the water carrier in the overarching heavens.

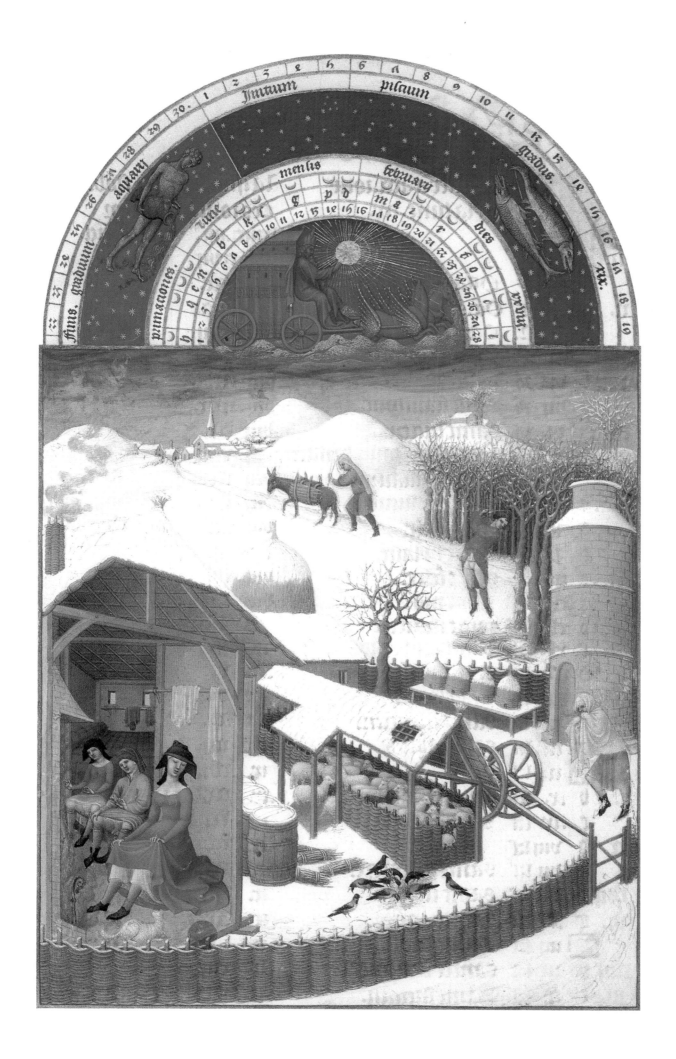

GIOVANNI BELLINI

Saint Francis in the Desert

c. 1485

OIL AND TEMPERA ON PANEL, 49" × 55⅞" (124 × 141.7CM). THE FRICK COLLECTION, NEW YORK CITY.

Giovanni Bellini (c. 1431–1516) was from a family of painters, and counted Giorgione and Titian among his students. They may have learned about the expressive qualities of light from their teacher, who came to landscapes late in his career but mastered them felicitously, as is evident in this painting. Distinct elements of this work—the rock face of the Saint's cave, the slope below the castle—seem to glow with their own light, and at the same time to convey the brilliant materiality of creation. The proud castle on the top of the hill in the left background and the stern tower below it look like toys compared to the timeless grandeur of the Saint's chosen place. Bellini has not depicted Saint Francis gazing at creation, as are the donkey and the heron in the middle ground, but has portrayed instead the feeling of transcendence that comes from contemplation. Francis has moved from wonder at the glories of creation to rapture in the mystery of the Creator.

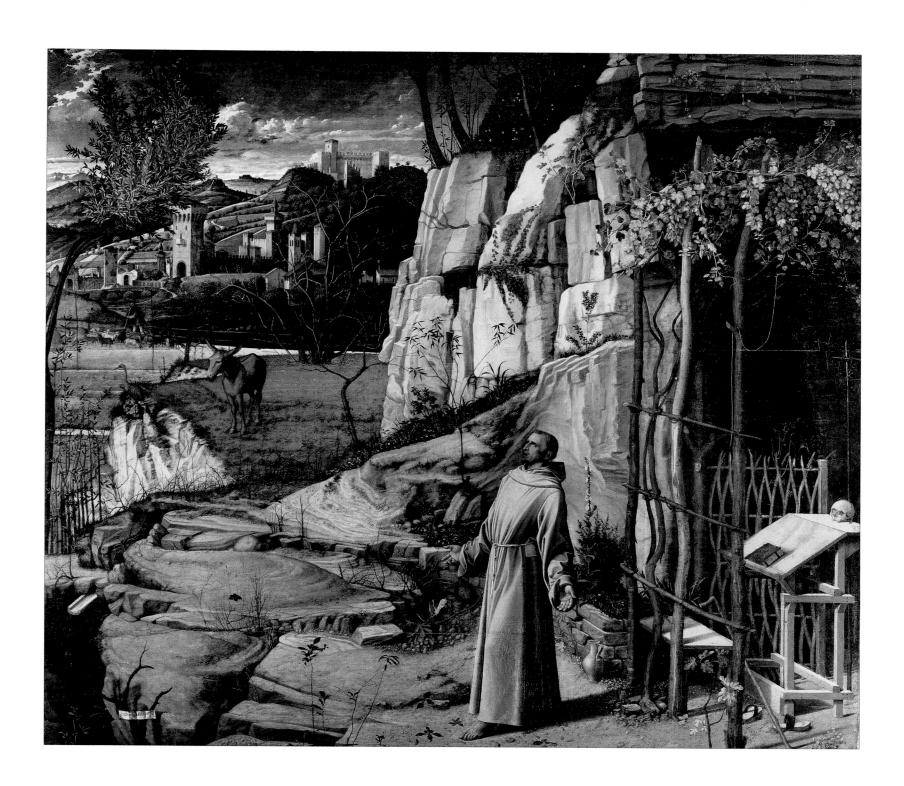

UNKNOWN

Dancing Dervishes

(Leaf from the *Diwan* [Book of Poems] of Hāfiz)

c. 1490

COLORS AND GILT ON PAPER, 11¾" × 7⅜" (29.3 × 18.4CM).
THE METROPOLITAN MUSEUM OF ART, ROGERS FUND, NEW YORK CITY.

*U*nder the sponsorship of a son of Timur (the great Turkic conqueror also known as Tamerlane), the city of Herat, in present-day Afghanistan, became the center of painting in the Islamic world from the fourteenth century into the early sixteenth. The dervishes, Muslim fraternities that arose in the twelfth century, became particularly important there during the Middle Ages. The poet Hāfiz (1325/26–1389/90) was associated with the dervishes, whom he often included in his works. Some dervish groups' practices centered upon devotion as an emotional and mystical experience, which could express itself in hypnotic, even ecstatic, states that included whirling or howling. The artist of this illustration from the *Diwan* (an anthology of Islamic poetry) created brilliant detail that praises the variety and beauty of creation in the principal ritual of the dervishes, "remembering God." In this rite, the celebrants whirl and dance—often to exhaustion—as the artist has shown vividly. Today, the dervishes are discounted by orthodox Islamic theologians, but they continue to worship the sublimity of the Almighty in their centuries-old fashion.

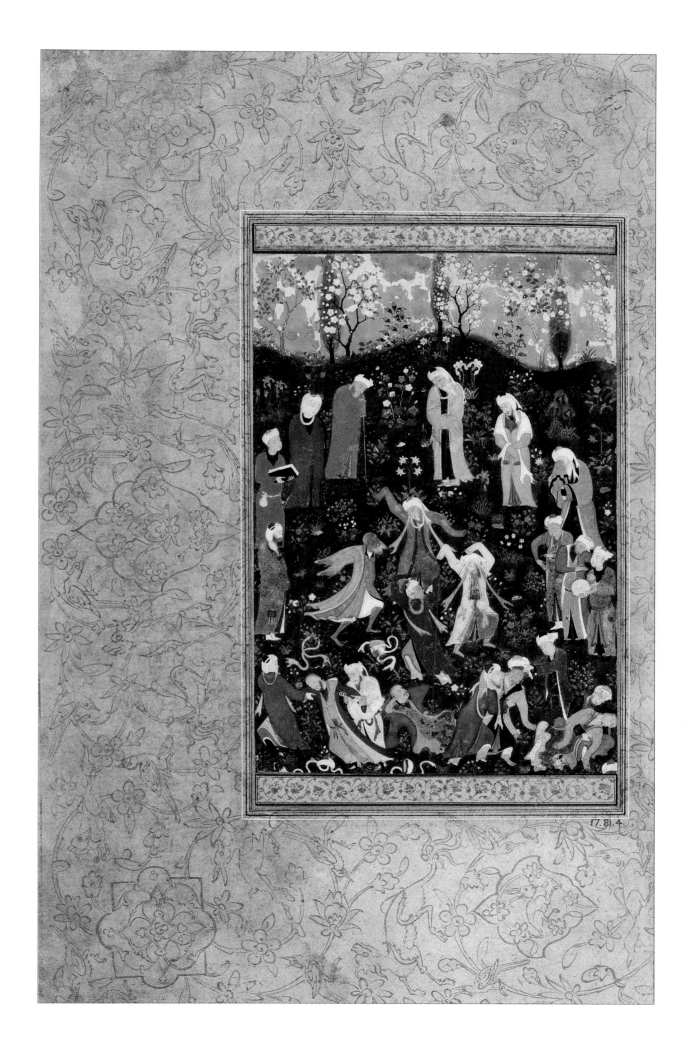

GIORGIONE

The Tempest

c. 1505

OIL ON CANVAS, 31¼" × 28¾" (78.1 × 71.8CM). GALLERIE DELL'ACCADEMIA, VENICE.

Arcadia—the lost paradise of rural peace—was a favorite subject of Giorgione (1478–1510). Here, it is transformed into a mysterious complex of images. The young, beautiful nursing mother evokes the Virgin with Child. Only partially clothed, but utterly pure, she also calls forth the opulently modeled lines of the classical Venus, an interpretation discreetly suggested as well by the broken columns of a ruined temple. But who is the fashionable young man in the watchful stance of a Christian angel? The distinction between the innocence of Arcadia and the loss of innocence represented by the city is explicit. Center stage, normally occupied by the protagonists of a painting, is here the site of light itself, and is also suggestive of absence. The storm threatens, a magnificent opportunity for Giorgione to display his mastery of shadow and mood. But perhaps it also stands for the cataclysm that was to carry away the classical world—with the birth of the Child Jesus.

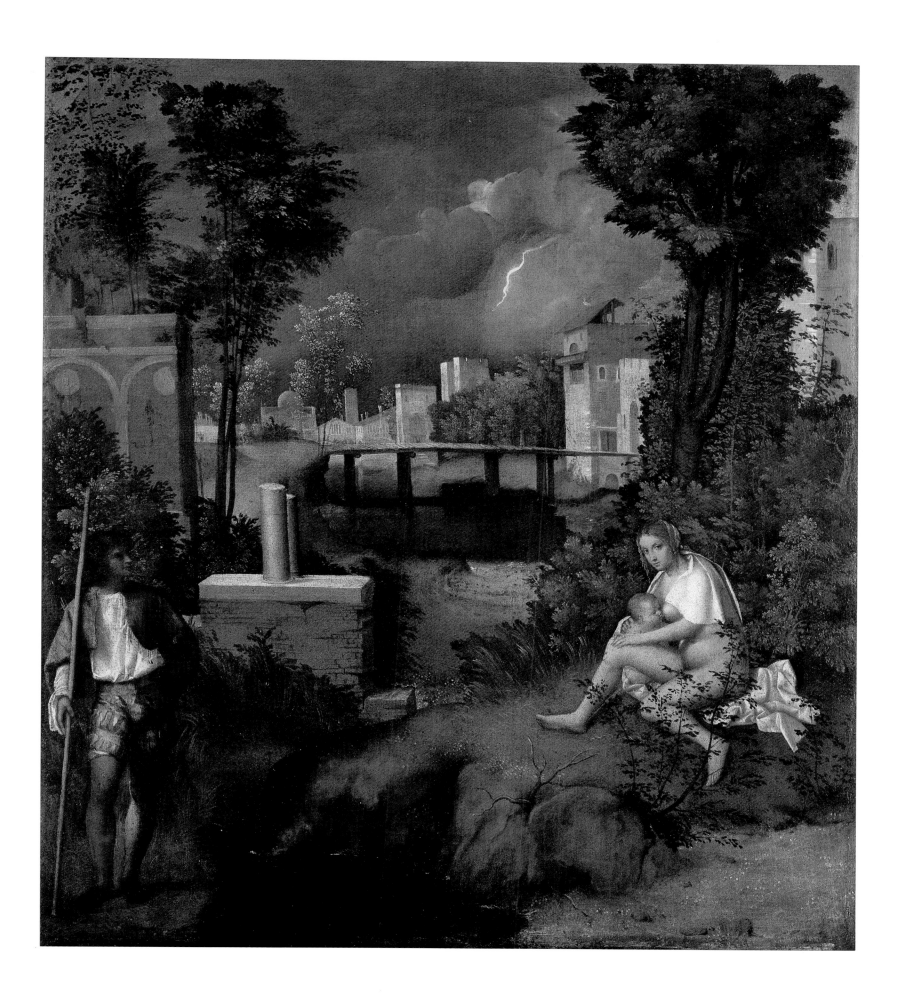

MICHELANGELO

The Fall of Man and the Expulsion from the Garden of Eden

1508–1512

FRESCO. CEILING OF THE SISTINE CHAPEL, THE VATICAN, ROME.

In this powerful vision of the Fall of Man, the Tree of the Knowledge of Good and Evil resembles a large, old fig tree, a common tree that Michelangelo (1475–1564) would have known well, as would all those assembled to hear Mass in the chapel of Pope Julius II. The Paradise from which the powerfully modeled couple are expelled is far more contained than the green, expansive world they are entering, however reluctantly; therein lies, perhaps, the ambiguity of original sin. Though Adam is too ashamed to even look at the Archangel Michael, he stands tall, while Eve, cowering and heartbroken, turns back with regret for the place of happiness they have forfeited. Though allotted along gender lines not unfamiliar to us today, the feelings of the pair are easily interchangeable, so true to life are the postures. Michelangelo the painter never ceased being a sculptor, and it is this closely observed emotion, depicted with almost blunt physicality, that gives Michelangelo's work its enduring and resonant humanity.

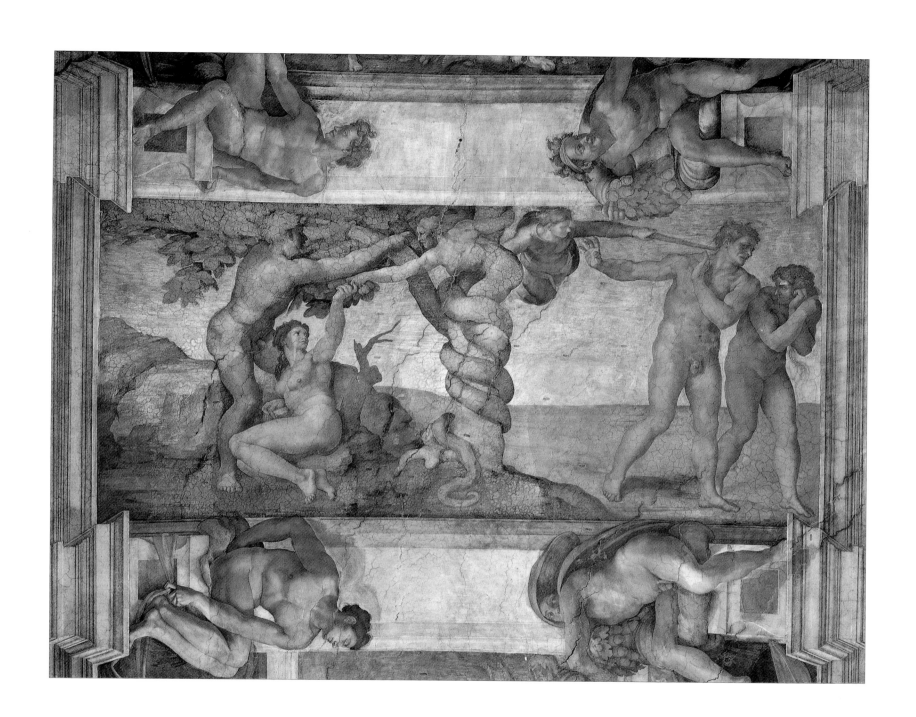

TITIAN

Bacchanal

c. 1518

Oil on canvas, 68⅞" × 76" (174.9 × 193cm). Museo del Prado, Madrid.

Titian, or, in Italian, Tiziano Vecellio (c. 1488–1576), was Venetian during that city's grandest age. A pupil of Bellini and a collaborator with Giorgione, Titian was most noted for his use of color and his powerful depiction of personality. He was internationally famous—his patrons included Pope Paul III, the Emperor Charles V, and the powerful Farnese family. His chief renown derived from his portraits, religious paintings, and paintings of mythological subjects.

Bacchanal, a boisterously pagan work, nevertheless retains some of Giorgione's spiritual grace in the landscape, trees, and sky. The orgiastic figures are youth and suppleness, set free by the wine that is Bacchus' gift to humankind. The only suggestion of the god's darker, destructive side is in the scrawny figure lying unconscious in the right background. We can imagine that these uncompromisingly beautiful and naked people are not so very far removed from the guests at an aristocratic Venetian dinner party.

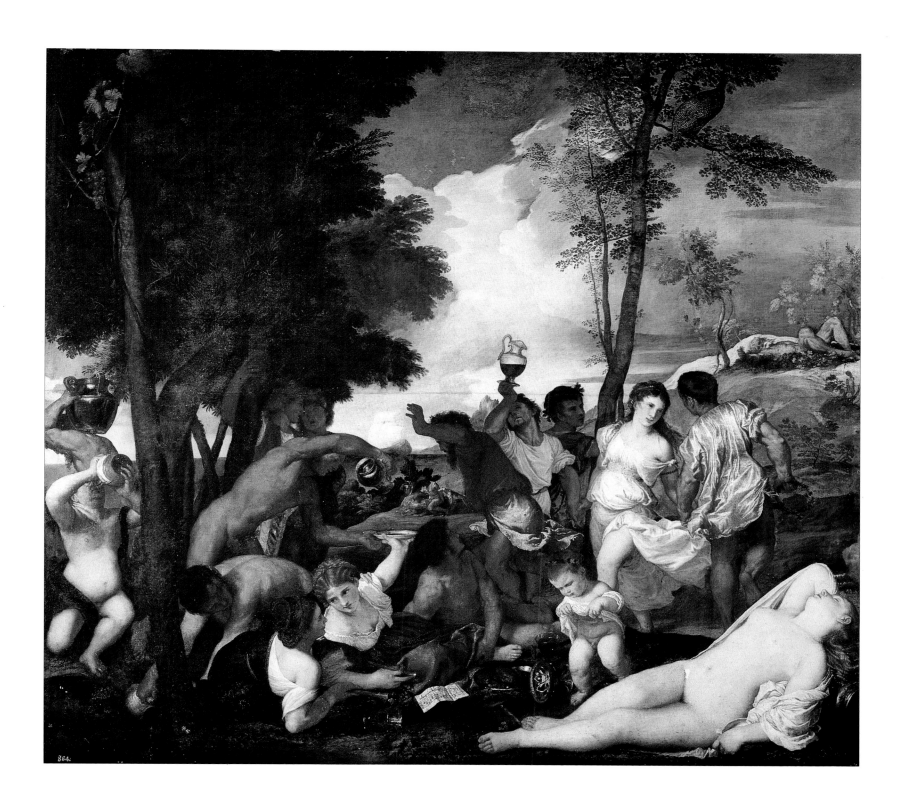

HANS WERTINGER

A Village Celebration

(also called *The Month of October*)

c. 1525–1530

OIL ON PANEL, 9" × 16" (22.5 × 40CM). THE HERMITAGE, SAINT PETERSBURG.

Hans Wertinger (c. 1465/70–1533) was renowned for his portraits of noblemen of the German royal courts, and for creating the first German painting based on ancient history. *A Village Celebration* represents a departure from Wertinger's official portraits, though his principal personages are still members of the gently bred class. The gold frame acts as an architectural element, a magic gateway into a land of plenty. In the foreground are merry lords and ladies, the former in fine boots of soft leather, the latter in pleated and trimmed gowns. They dance and flirt, and observe the peasants' revels across the river. It is a scene of prosperity—even the gooseherd in the right middle ground is elegantly behatted. Behind the church, stalls are set up, along with a shaded place to drink and long tables laden with the bounty of the season. The townspeople are like actors on a distant stage, performing for the amusement of the aristocratic onlookers. Looking more closely, we see examples of violence, industry, and piety—the myriad permutations of human nature—pictured in a wealth of detail that owes much to the vivid miniatures of illuminated manuscripts.

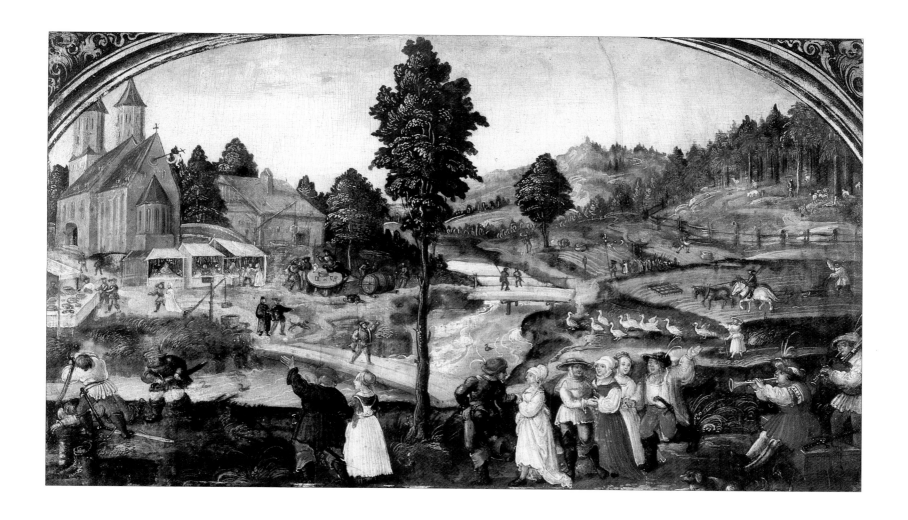

PIETER BRUEGHEL THE ELDER

Peasant Wedding

c. 1565

OIL ON PANEL, 44⅞" × 64" (112.1 × 160CM). KUNSTHISTORISCHES MUSEUM, VIENNA.

In this accomplished work by Flemish master Pieter Brueghel the Elder (c. 1525/30–1569), the bride stands out in her solitude amid the bustle of a hearty wedding banquet. Frail, pale, and young, she is no longer a maid, not yet a wife. The painter has seated her before a curtain, flanked by turbaned women, in an ambiguous reference to traditional representations of the Virgin Mary and the mystery of the Immaculate Conception. With all the fleshly appetites implied by the buxom and rotund figures, Brueghel's understatement in the figure of the bride emphasizes the physical union that will be the culmination of the festivities for the young woman. The feast has a coarse, oddly joyless quality that bodes ill for her wedding night and future life. In his unromantic depiction of human appetites, Brueghel seems to be acidly questioning the traditional artistic and social connotations of nature as somehow more noble than society. The peasantry, the class conventionally deemed closest to nature, is shown here free from the expensive artifices of their "betters," seeming heavy and, except for the bride, earthbound. Their manners may be rough, yet their appetites are universal, and this occasion that should be filled with joy delivers a deeply pessimistic portrait of human nature.

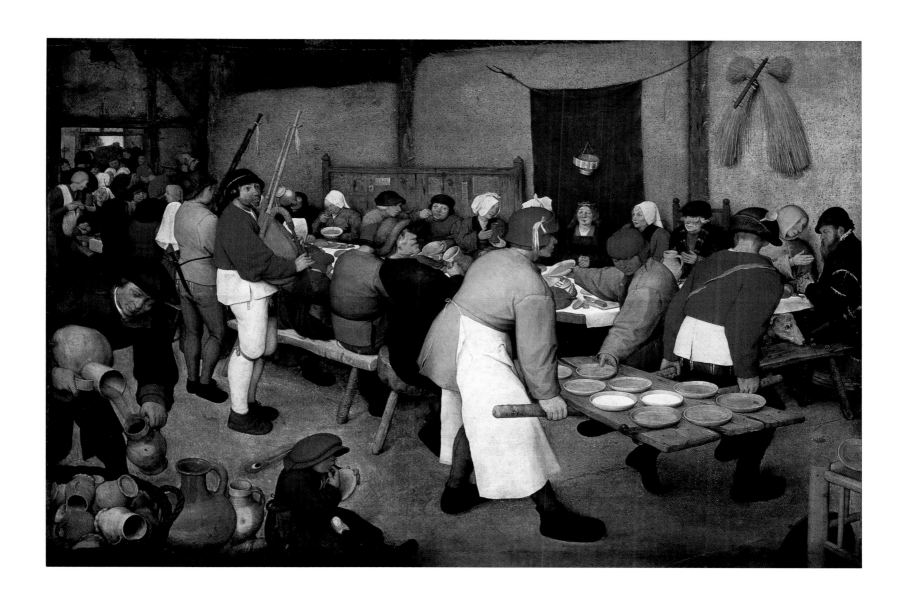

CLAUDE LORRAIN

Landscape with Merchants

c. 1630

Oil on canvas, 38¼" × 56½" (97.2 × 143.6cm). Samuel H. Kress Collection, National Gallery of Art, Washington, D.C.

Claude Lorrain (1600–1682) left his native France for Rome around 1615, becoming famous for his Arcadian, or ideal, style of landscape. He was the first painter to use the sun as a source of light, and was known for the atmosphere that he was able to effect in his works, which influenced artists for centuries. Claude sometimes had his assistants fill in figures, a Renaissance work habit of the artist that contrasts with the later, Romantic character of the artist as solitary visionary. It was not until Claude's time, and perhaps because of Claude, that landscapes were accepted as worthy subjects for painting in Europe. In *Landscape with Merchants*, the figures are dressed like Claude and his contemporaries; elsewhere in his oeuvre they wear somewhat theatrically imagined classical garb. The soft blush of the morning sun and the distant, evanescent horizon lend a dreamlike quality to this scene of merchants setting out for faraway, perhaps even legendary, places.

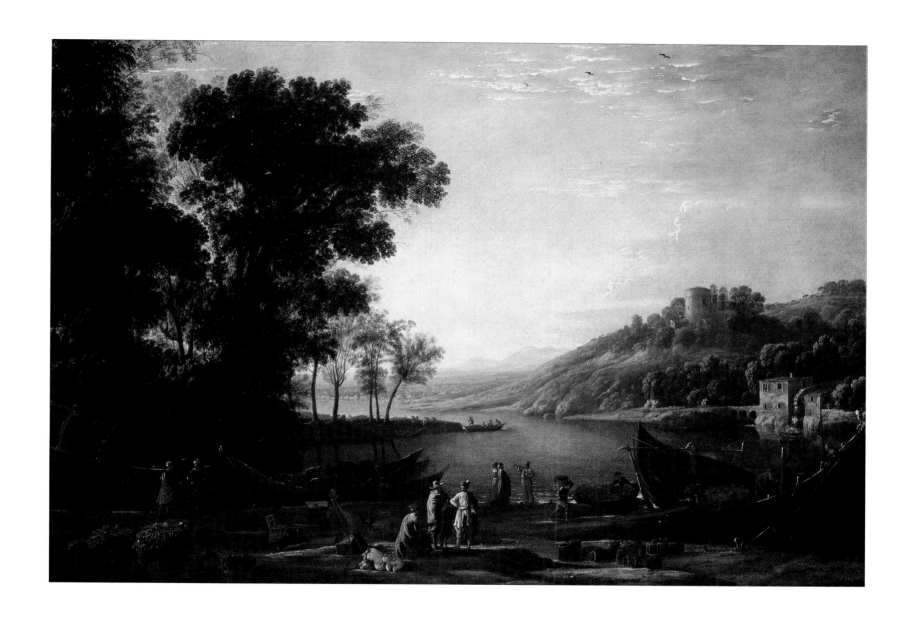

PETER PAUL RUBENS

Landscape with the Château of Steen

1636

OIL ON PANEL, 53" × 93" (134.5 × 236.7CM). THE NATIONAL GALLERY, LONDON.

Peter Paul Rubens (1577–1640) became a master painter in Antwerp in 1598, when he was twenty-one, but it was in Rome that his talents truly flowered. There, for eight years, he studied the ancients as well as the most gifted of the Renaissance artists, establishing himself on a par with his Italian colleagues. At the turn of the seventeenth century, the world of European art was in a ferment that produced the theatrical, even heroic, physical ebullience of the Baroque, and Rubens was in the forefront of the movement. Returning to Antwerp, he was instantly successful as both a painter and a diplomat. In the 1630s, Rubens acquired the Château of Steen—shown here discreetly but lovingly tucked away on the left—and in his new life as a country squire, he developed a renewed interest in landscape painting. Note the curious vantage point: we are surprisingly high up, not only with respect to the hunter and the country couple in their cart, but also to the flat countryside that extends peaceably to the horizon.

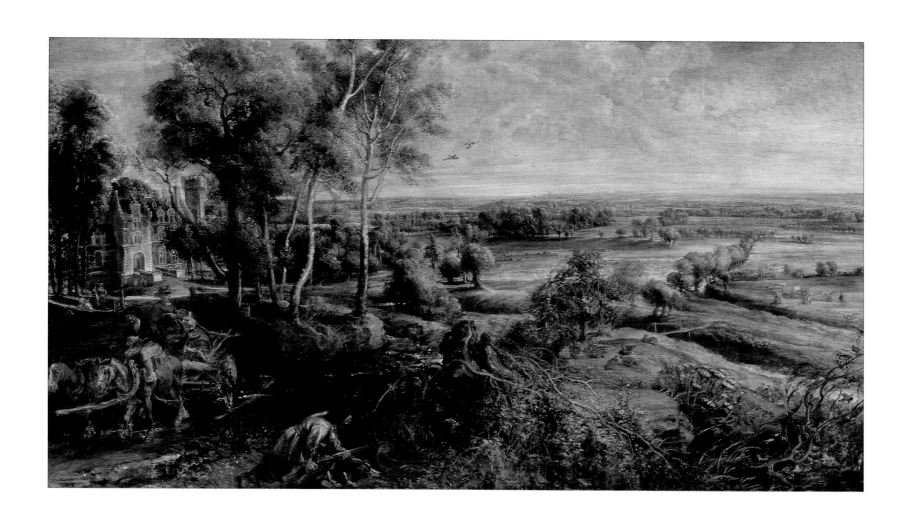

FRANS DE MOMPER

Environs of Antwerp

Date Unknown

OIL ON CANVAS, 23" × 32" (58 × 81CM). THE HERMITAGE, SAINT PETERSBURG.

The city of Antwerp was a prominent center for painters in the sixteenth and seventeenth centuries, and it was here that de Momper (1603–c. 1660) became a master in 1629. It was also a thriving port city, though no longer the commercial capital of Europe, as it had been some one hundred years before this painting was made. Here, we see the outskirts of a thriving center—the artist has camouflaged Antwerp's skyline among the gray verticals of the winter trees. The diagonal line of the road gives energy to the painting, and, by association, to the traveler; the covered wagon may belong to a merchant heading for town. It is winter, but not a bitter one: the woman coming out from the compound of houses on the left is in street clothes, and plumes of smoke rise placidly from the chimneys, but only from some—though snug, the houses are not wastefully heated. Moderation and comfort characterize this well-managed, virtuous suburb—in contrast, the artist implies, to the more extreme, bustling rhythms of the nearby city.

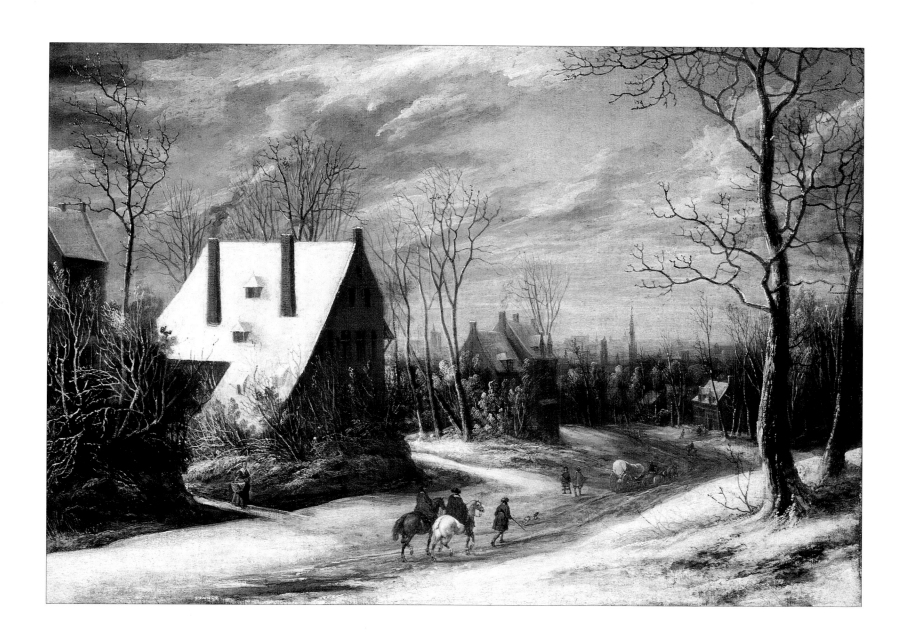

LOUIS LE NAIN

Peasant Family

c. 1640

OIL ON CANVAS, 44½" × 62½" (111.2 × 156.2CM). MUSÉE DU LOUVRE, PARIS.

This striking family portrait combines naturalist detail and incidental still lifes—such as the pot on the floor—with mixed assumptions about social stations, or classes. The focus of the composition is the very beautiful young boy playing a small reed pipe; on the right, his brother is equally cherubic. Their sister seems plain, but the future holds the promise of both her mother's arrestingly handsome features and her grandmother's slightly severe dignity. These are prosperous peasants: the grandmother holds a fine wine glass in her hand; the child on the left, with his back to us, and the girl to the right of the fireplace may be servants. The coarse-featured father is hardworking and parsimonious—he holds the loaf that he is cutting with an almost protective grasp. This portrait was surely not painted for the family it portrayed; whatever patron purchased it would be reassured as much by the sitters' material comfort as by the stereotypes portrayed, however masterfully.

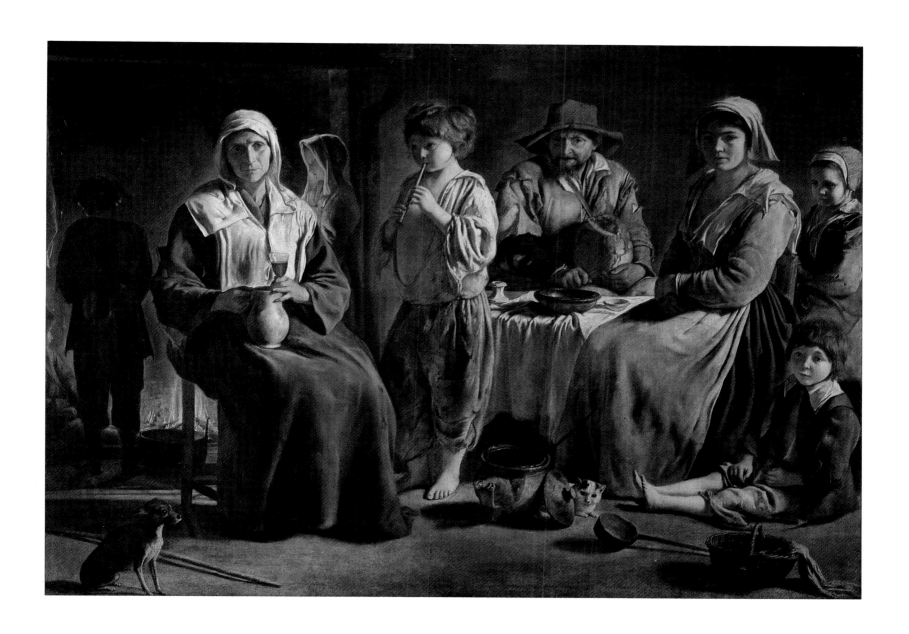

AERT VAN DER NEER

A River in Winter

c. 1640

OIL ON PANEL, 14" × 24½" (35.5 × 62CM). THE HERMITAGE, SAINT PETERSBURG.

Van der Neer (1603/4–1677) was known for his night scenes of waterways, his inclination for monochromes, and the openness of his compositions. An overall warm gold, accented with browns and other earthy colors, lends an intimate quality to this scene of winter ease. People are pictured at play, skating, engaging in a kind of hockey, or, in the case of the child in the left foreground, ice-boating, all in a reverie so wholehearted that we are swept into it ourselves.

Gingerly, a dog walks stiff-legged on the slippery surface, while a man wheels kegs of ale, no doubt to a tavern. Van der Neer himself was listed as an innkeeper from 1659 to 1662, and as a painter only in the year of his death. A few touches of red, in a woman's skirt, a man's belt, and another man's hat, save the work from literally falling into a brown study.

The prominent windmill tells us that this is a farming community, and winter the season of well-deserved leisure.

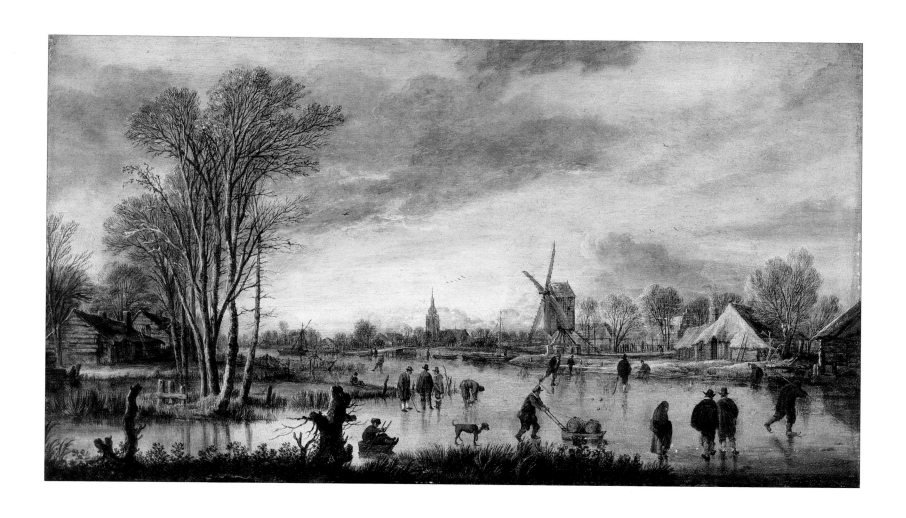

JOHN WOOTON

Dogs and a Magpie

c. 1733

OIL ON CANVAS, 50" × 60" (128 × 152CM). THE HERMITAGE, SAINT PETERSBURG.

The size of this painting underscores the importance of its subject. During Wooton's lifetime (c. 1686–1765), British lords of the manor still possessed the sole right to hunt both on their lands and on those of their tenants. Poachers were severely punished, not only for the crime of theft, but also for the crime of usurping the prerogatives of their "betters"—a transgression that reverberated menacingly throughout the social order. Given the social importance of hunting, it is unsurprising that Wooton was commissioned to paint a portrait of the patron's hounds, prized by their owner, cared for by the Master of the Hounds and his staff. The artist has set them against a dramatic landscape that extends to an almost mythic-looking peak in the far distance, a tribute to the proprietor's vast holdings and power. Against this background, the artist has posed the animals to their best advantage: connoisseurs can admire the shapes of haunch and head, signs of good breeding. In the right foreground, Wooton, true to his century, has composed a meticulous still life that would not be out of place in an herbal.

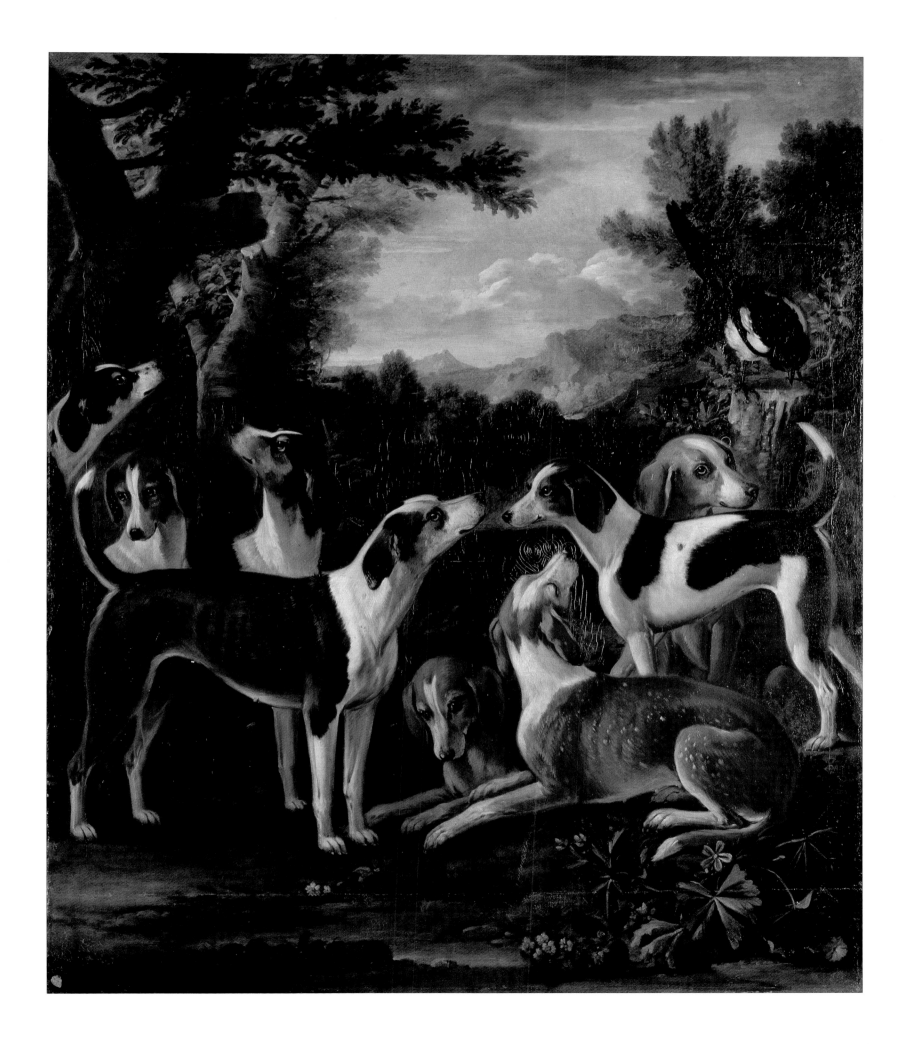

THOMAS GAINSBOROUGH

Robert Andrews and his Wife

(also called *Mr. and Mrs. Andrews*)

c. 1749

OIL ON CANVAS, 28" × 47½" (70 × 119CM). THE NATIONAL GALLERY, LONDON.

Painted by the great English portraitist Thomas Gainsborough (1727–1788), this work derives much of its tender charm from the feeling it conveys—that the sitters asked the artist to portray elements that had personal meaning to them. The idyllic quality suggests that theirs is in every way a suitable alliance, in which affection and a harmony of tastes and values prevail. They seem to be *good* people: the dog looks adoringly at its master; the land appears to prosper. And it is a great deal of land—the Andrewses are gentlefolk. Indeed, the portrait is as much or more about their property as it is of them; the way the painter has composed the picture makes it clear that the land is much more to them than a source of pride; rather, it supplies their identity, their responsibility, their place in the divine scheme. Yet these people are not country provincials: the panniers of Mrs. Andrews' simple day dress, displayed as she sits on the elaborate wrought-iron bench, are wide enough for any London afternoon.

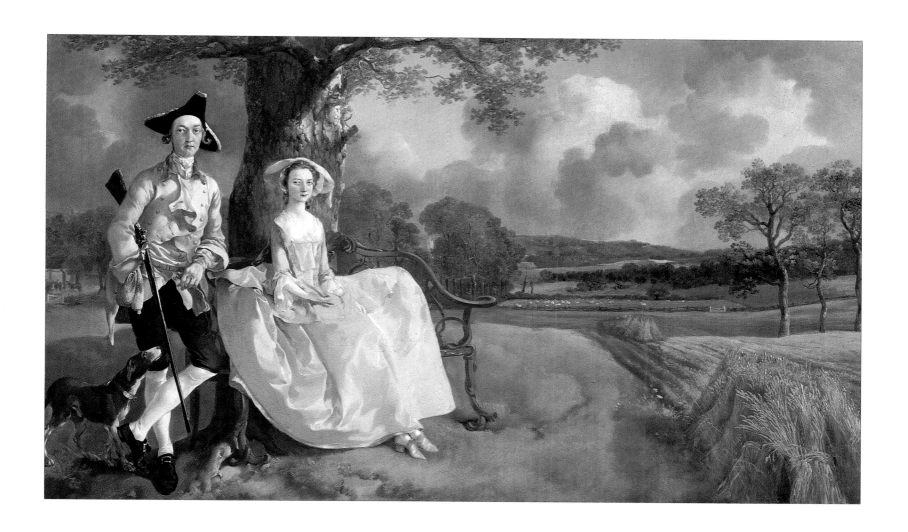

ANGELICA KAUFFMANN

The Family of Ferdinand IV

c. 1782–1784

OIL ON CANVAS, DIMENSIONS UNAVAILABLE. MUSEO NAZIONALE DI CAPODIMONTE, NAPLES.

Angelica Kauffmann (1741–1807), one of the original members of the British Royal Academy, was known for her portraits as well as for pastoral, historical, and Neoclassical paintings. Here, she draws on all these styles and subjects, as well as on a deft sense of character. The artist displays an almost theatrical flair for mise-en-scène—witness the unspecified architectural prop against which the King of Naples leans casually, looking down upon the viewer, as does his wife and resolute counselor, Maria Carolina of Austria. He is in every sense a *paterfamilias*—standing, surrounded by his six children. His hand on his heart proves him also a man of sensibility, a much-prized eighteenth-century virtue. Clouds loom behind the family group, a favorite Romantic sign of the emotionally authentic human being. Faithful dogs frolic in the foreground, while the romanesque towers in the background vouch for the Spanish-born ruler's legitimate sovereignty over the southern Italian land that was Ferdinand's realm.

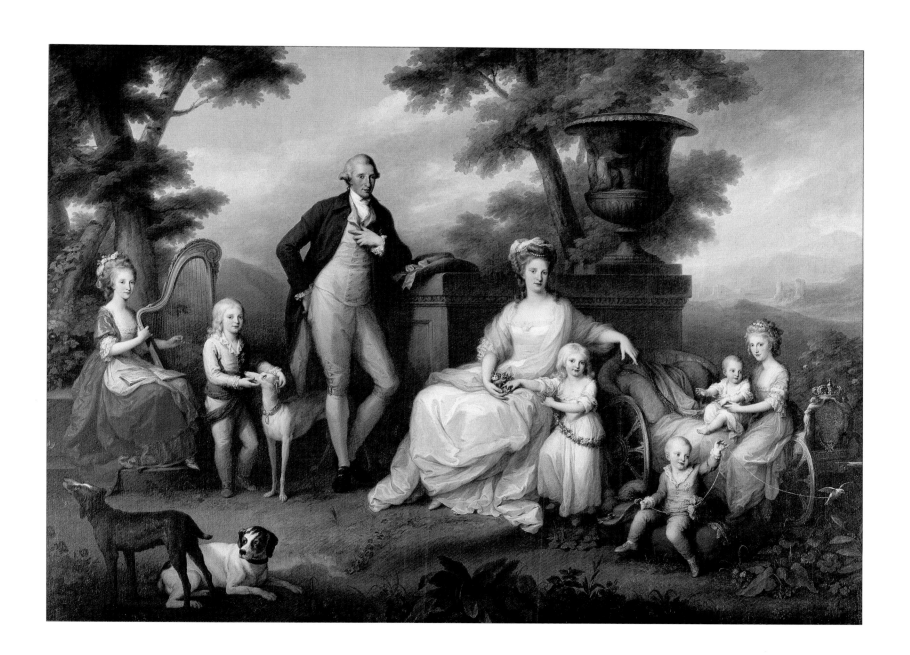

John Constable

Stoke-by-Nayland

1836

Oil on canvas, 49½" × 66½" (126 × 168.8cm). Mr. and Mrs. W. W. Kimball Collection, The Art Institute of Chicago.

Although John Constable (1776–1837) showed his paintings at the British Royal Academy as early as 1802, he received little popular acknowledgment in England. His work was welcomed in France, however, where he received awards in 1824 and 1825. One of the earliest generation of artists to work outdoors, Constable made oil sketches using the plein air ("open air") style, but completed his paintings in his studio. Paradoxically, the precision he brought to capturing the fleeting effects of light and atmosphere gave Constable's works a heightened emotional quality typical of the Romantics. Constable's favorite subject was rural England. In *Stoke-by-Nayland*, a country lane winds past the viewer. The town of the title is marked by the bell tower of its church, visible above the trees in the distance. There is no far horizon, which contributes to the work's intimate quality, its feeling of bringing us into the neighborhood. The figures seem relaxed and content to take in the moment; cows wander freely. It is easy to imagine that this village encompasses its inhabitants' entire world—and that for most of them, it is world enough.

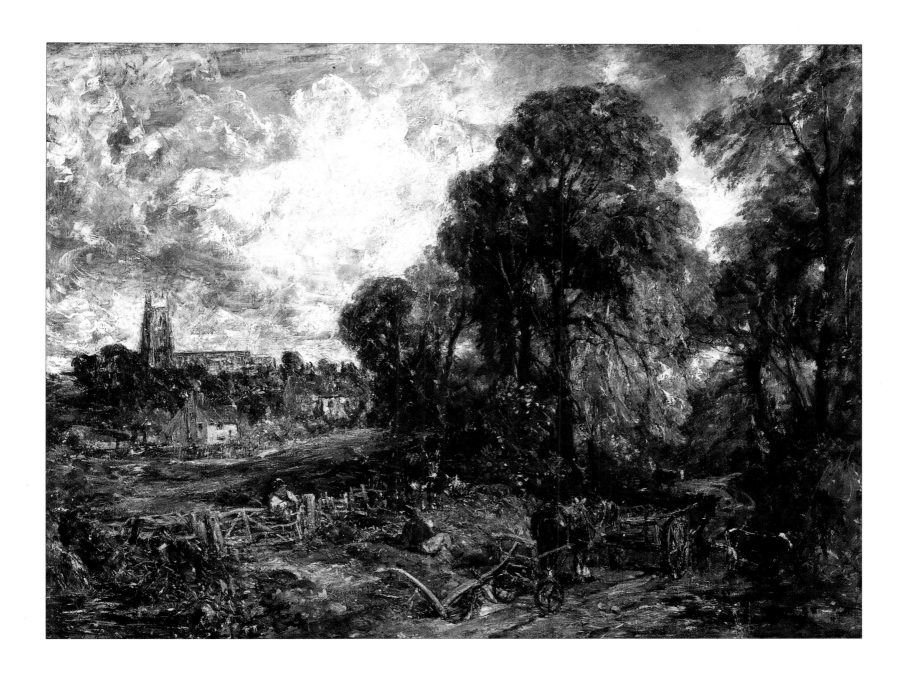

ROSA BONHEUR

Plowing in the Nivernais

1849

OIL ON CANVAS, 69" × 104" (172.5 × 260CM). MUSÉE D'ORSAY, PARIS.

Rosa Bonheur (1822–1899), the first woman to be awarded the Grand Cross of the Légion d'Honneur (in 1865), was best known for her paintings of animals. In *Plowing in the Nivernais*, the marked foreshortening emphasizes the oxen's vigor and contoured muscles, while it diminishes the presence of the farmer, who directs the power he has literally yoked. But the artist also suggests the oxen's strength by the depth of the furrows in the foreground, fruit of the beasts' labors. The fact that this picture was made in 1849, only a decade after photography was announced almost simultaneously in England and France, enhances our understanding of its accomplished realism through a greater awareness of the artist's imagination and intent. And the year before, in 1848, the Republic had been proclaimed in France, reflecting the increasing political presence of an urban proletariat and of the bourgeoisie. Though she painted a sturdily unsentimental portrait of a still predominantly agricultural culture, Bonheur might have been foreseeing—nineteen years after the invention of the steam locomotive—the disappearance of a timeless age.

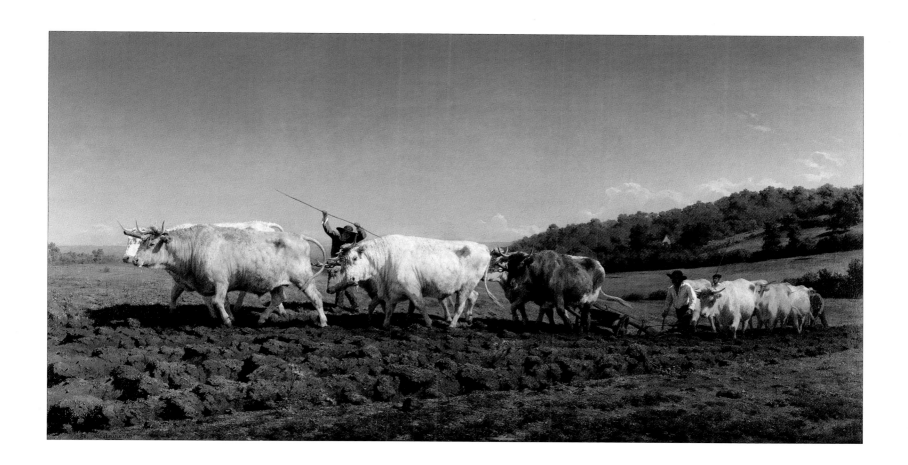

CLAUDE MONET

On the Seine at Bennecourt

1868

OIL ON CANVAS, 32⅛" × 39⅝" (81.5 × 100.7CM). MR. AND MRS. POTTER PALMER COLLECTION,
THE ART INSTITUTE OF CHICAGO.

*M*onet (1840–1926) was not yet thirty when he painted this serene, sunlit moment, before the term "Impressionism" was coined in 1874. The artist invites us to view a country town and, perhaps, engage in the ageless reflection on the differences between town and country, nature and civilization. We might be standing on the riverbank ourselves, sharing the contemplative mood of the seated figure, who may have rowed over for this purpose. Monet was one of the first painters to leave the studio—and the conventions of the Academy—in order to paint in plein air style. Indeed, the effect of the light is as dazzling as if we, too, had emerged from a dimly lit room. The painterly tricks, such as modeling for a three-dimensional effect, are few and deployed with precise restraint. As in the work of his predecessor Manet, there is nothing "photographic" about Monet's rendering of a persuasive illusion. On the contrary, we are aware of the materials, even as we succumb, delighted and refreshed, to the effect Monet has skillfully constructed.

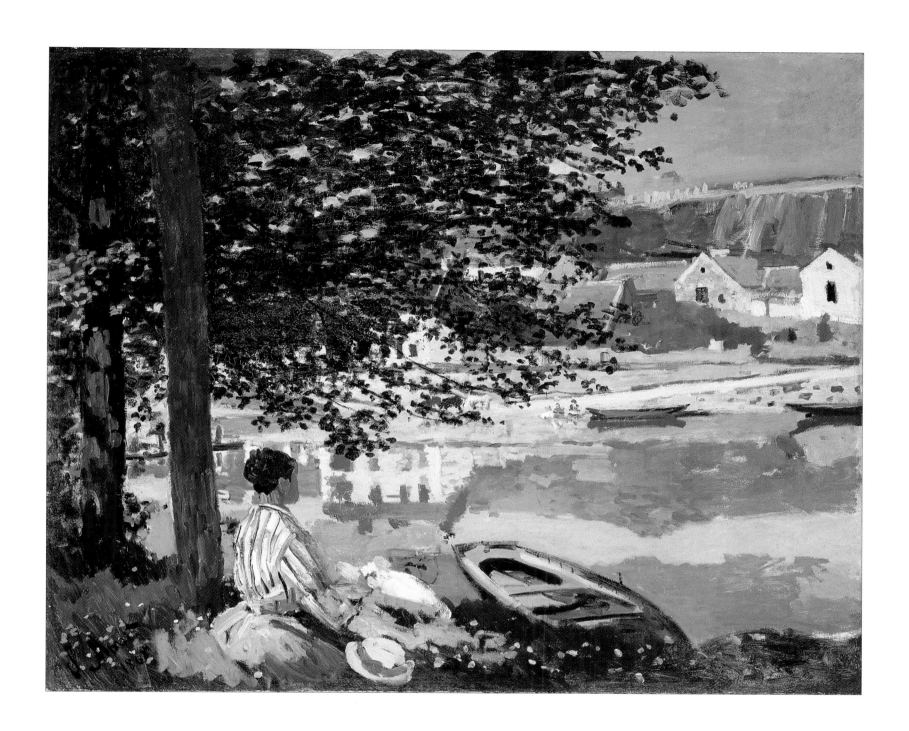

VINCENT VAN GOGH

Wheat Field and Cypress Trees

1889

OIL ON CANVAS, 28½" × 36" (72.3 × 91.3CM). THE NATIONAL GALLERY, LONDON.

Vincent van Gogh (1853–1890) came to painting relatively late, after attempting to channel his intense spiritual drive

into working as an evangelist among the poor. His brother, Theo, who would later in large measure support him, owned

a gallery of modern art in Paris, where Vincent met most of the luminaries of this turbulent era. Van Gogh's

Impressionism is more emotional than that of his fellow artists, calling attention less to the components of art than to

the feelings that he projected into the elements in the landscape. There is no neutral part of his work, no piece that does

not swirl and vibrate and flare with nerves and the varied essences of nature. The wheat field is golden, as if it had

absorbed, all summer, the lavish heat and light of the Mediterranean sun. We can almost taste the equally golden bread

the grain will make, sustaining and blending existence and pleasure. In his mid-thirties, van Gogh was already suffering

from the mental illness that would increasingly alienate him from the people around him and from his art. The year after

this work was painted, van Gogh committed suicide.

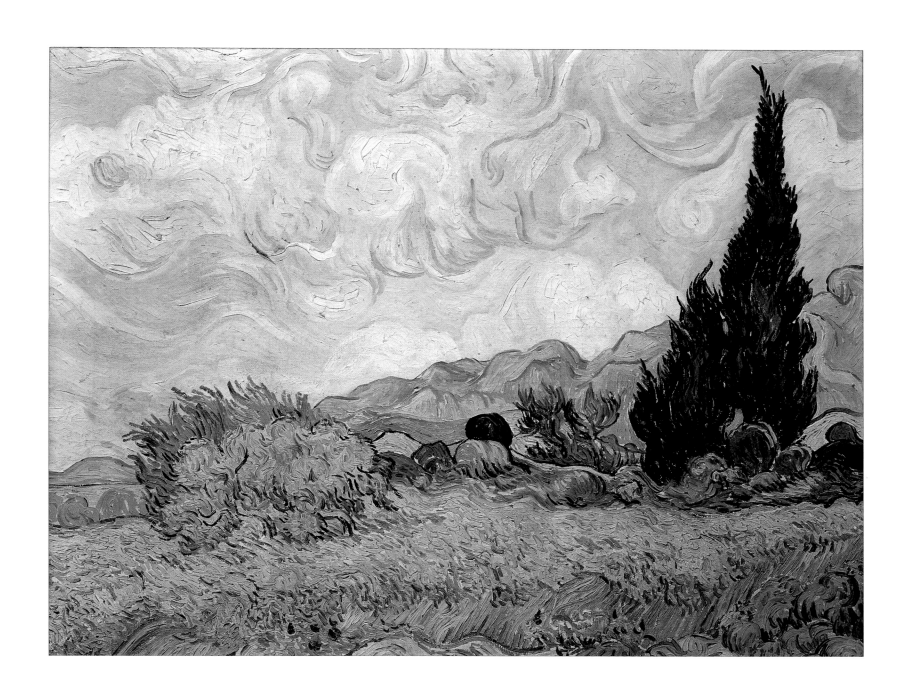

MARC CHAGALL

I and the Village

1911

OIL ON CANVAS, 75⅝" × 59⅝" (192.1 × 151.4CM). MRS. SIMON GUGGENHEIM FUND,
THE MUSEUM OF MODERN ART, NEW YORK CITY.

Classically trained at the Imperial School of Fine Arts in Saint Petersburg, Russia, Marc Chagall (1887–1985)

moved in 1910 to Paris, where the Fauves, the Cubists, and the Surrealists had in turn shocked the art establishment.

Influenced by their works, Chagall brought to his art, with charm and joyous spirituality—and in a dazzling number of

media—his experience of the country towns of Russia. Here, Chagall portrays his hometown of Vitebsk with a kalei-

doscopic series of images of dreamers. At the top, a farmhand returns to town with his scythe; perhaps he sees his future

wife, in a vision blessed by the priest in the door of the church. The ringed hand at the bottom holds a magic branch,

while the milkmaid's wistful thoughts are her own. Or is she imagining the cow on the left turning into the young man

on the right? And just who is the "I" of the title?

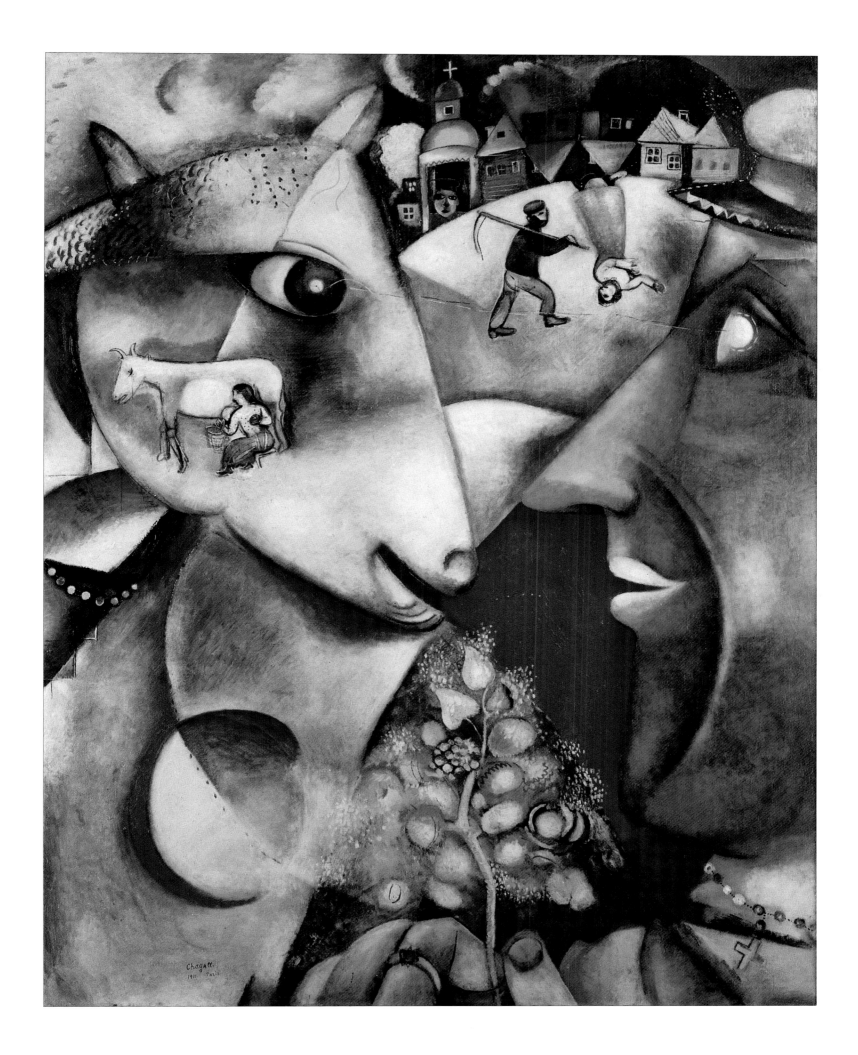

JOAN MIRÓ

The Farm

1921–1922

OIL ON CANVAS, 48¾" × 55⅝" (123.8 × 141.3CM). GIFT OF MARY HEMINGWAY, NATIONAL GALLERY OF ART, WASHINGTON, D.C.

Joan Miró (1893–1983) was in many ways a happy and fulfilled human being, from a loving family and blessed with a happy marriage, and a successful artist from early in his career. By far the most agonizing aspect of his life was his fervent, searching endeavor to render his vision. He pursued this quest with a desperate, nearly religious hunger. Yet his inspiration—like that of Walt Whitman, whom he admired—was the wonder of daily life and its everyday objects. It has been observed that in *The Farm* nearly every element is literally underlined in order to emphasize its singularity as an expression of a universal spirit. The exception is the baby at the center of the farm, who is set off by a surrounding empty expanse, and is connected, by the artist's rigorous geometry, to the tree, which grows from the light and dark, the sun and the good black earth, consciousness and mystery.

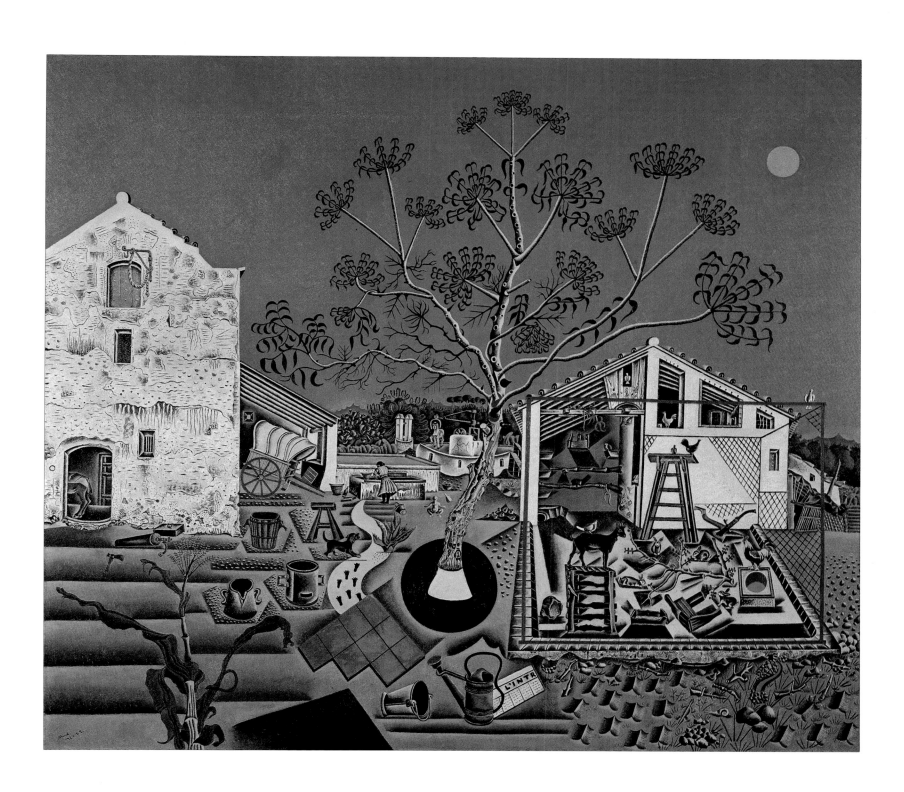

GABRIELE MÜNTER

Staffelsee in Autumn

1923

OIL ON BOARD, 13¾" × 19¼" (34.3 × 48.1CM). THE NATIONAL MUSEUM OF WOMEN IN THE ARTS, WASHINGTON, D.C.

In 1911, Gabriele Münter (1877–1962) helped found *Die Blaue Reiter*, or "The Blue Rider," a group of Munich artists united by a commitment to using color to express emotions directly and powerfully (though the individual styles of the group's participants, including Vassily Kandinsky, Paul Klee, Franz Marc, and August Macke, remained distinctive). In its mature, rich palette and bold areas of color, Münter's painting of hills blazing in autumn glory can be described as "expressionist." This term was originally coined for the Fauves, or "wild beasts," of the Paris Salons some two decades earlier. *Die Blaue Reiter* reiterated and took even further their forebears' insistence on the primacy of an artist's perception of the subject. With *Stafelsee in Autumn*, Münter's response to the landscape is so vivid and specific that we feel we are viewing a portrait of a particular moment in time and space in all its uniqueness.

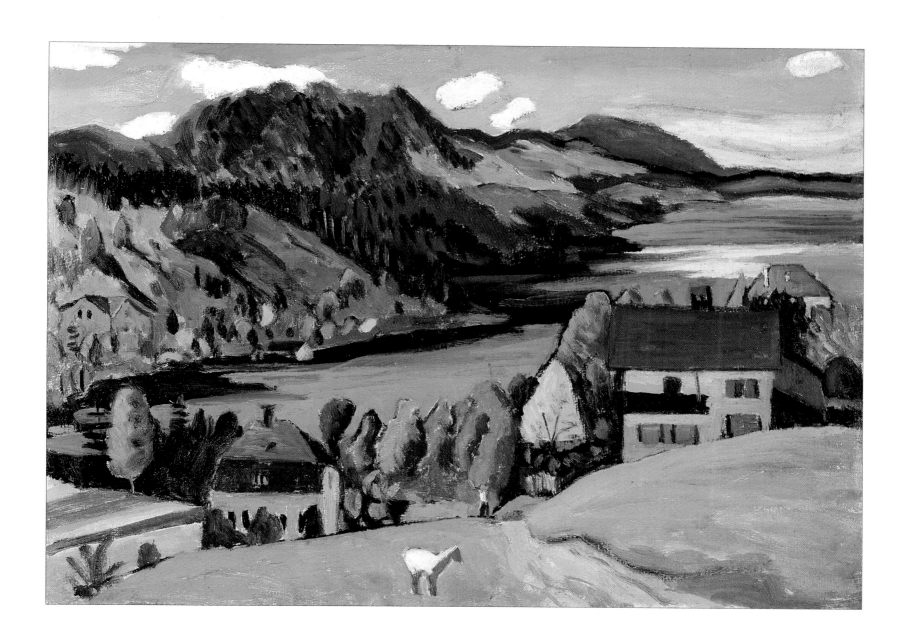

CÂNDIDO PORTINARI

Café

1935

OIL ON CANVAS, 51" × 77" (130 × 195.5CM). MUSEU NACIONAL DE BELLAS ARTES, RIO DE JANEIRO.

Cândido Portinari (1903–1962), the son of immigrant laborers, was born on a coffee plantation. Initially admired

for his portraiture, he won a fellowship to travel through Europe, and by the mid-1930s was better known for his

murals. Portinari fulfilled several commissions in the United States, most notably for the Hispanic Foundation of the

Library of Congress in Washington, D.C., and for the United Nations Building in New York City. Inspired by the Mexican

muralists and their social concerns, Portinari depicted typically Brazilian scenes. Here, the forced perspective works to

emphasize the size of the plantation and the number of people required to harvest the coffee, bean by bean, sack by sack.

The artist's intimate knowledge of the anatomy of every task shows in the bodies of these workers, from the torsion of

a hip to the exhaustion in a seated figure. The characters' bare feet convey a sense of endurance and physical strength.

The workers' broad shoulders and proud stances reveal the dignity of their labor, despite the overseer who climbs a palm

tree to supervise them.

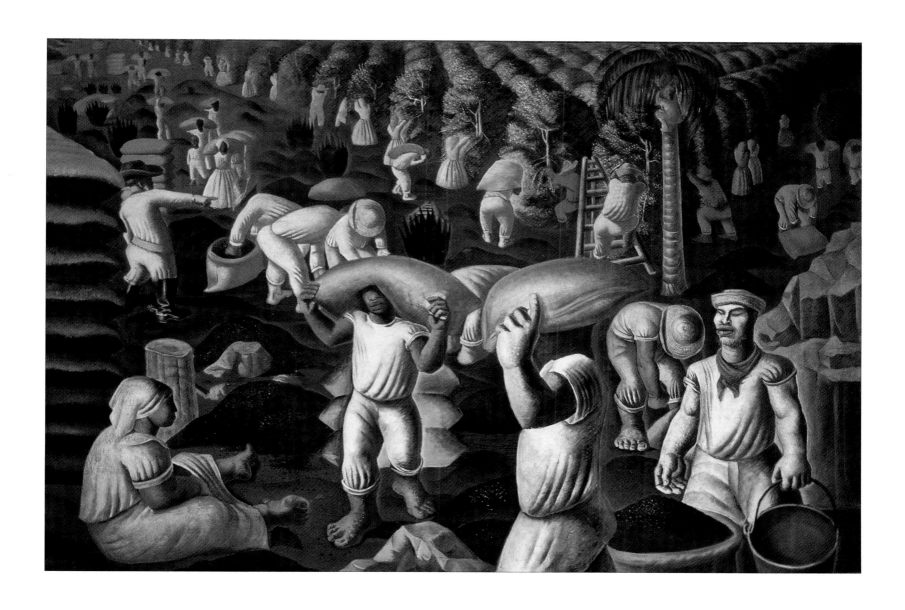

WILLIAM H. JOHNSON

Early Morning Work

c. 1940

OIL ON BURLAP, 38" × 45⅝" (95 × 114CM). NATIONAL MUSEUM OF AMERICAN ART,
SMITHSONIAN INSTITUTION, WASHINGTON, D.C.

William H. Johnson (1901–1970) was virtually unknown in his native United States until the mid-1960s, in part because he lived abroad much of his life, first in Paris, then in Denmark. His clean, unequivocal, but thematically rich and neoprimitive style, however, fits squarely into the mainstream of American modernism. The yellow tones cast a glow of contentment over this scene of family work. The children, with a youthful sense of occasion, face front as if for a portrait photograph, holding the pails they use for their chores; their father is too preoccupied to turn as he readies the horse for the fields. This farm, a place of industry and orderliness, resembles a child's drawing in the deliberately drawn horizontal lines on the house and the verticals of the picket fence. But the composition is meticulously studied; the cartoonlike chickens stem from an adult's sense of fun; and the diagonal shapes of the washing on the line reveal an adult's memories of warm sun and breezes. Might this be the artist's wistful view of an American childhood and family— a dream-portrait of himself as a young man?

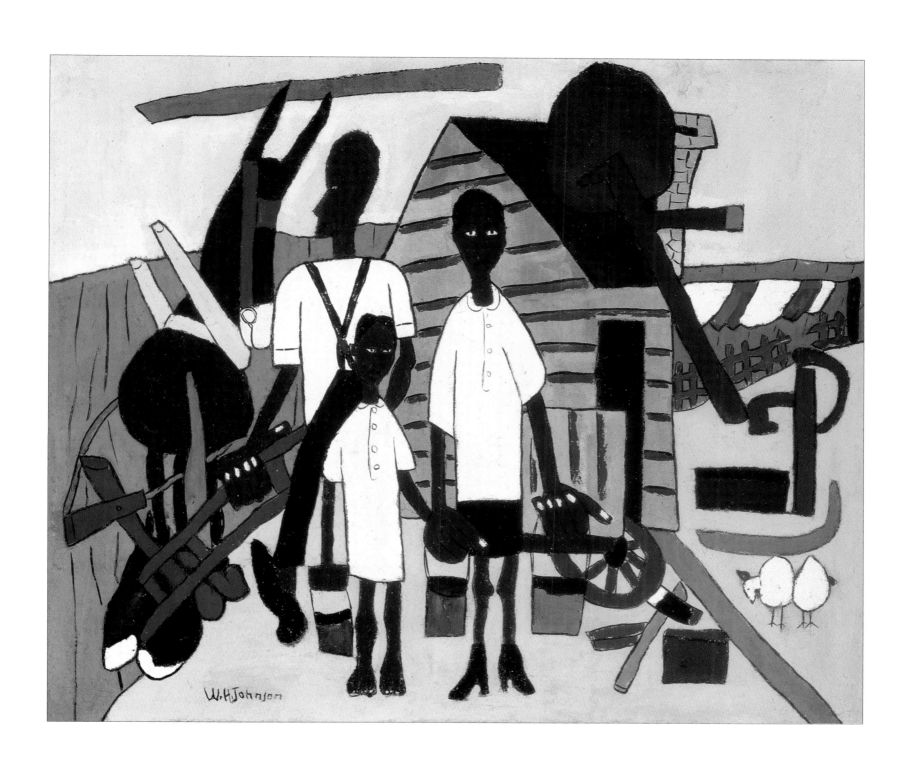

HORACE PIPPIN

Night Call

c. 1940

OIL ON CANVAS, 28⅛" × 32⅛" (70.3 × 80.3CM). ABRAHAM SHUMAN FUND, MUSEUM OF FINE ARTS, BOSTON.

Horace Pippin (1888–1946) was in the tradition of American folk artists: self-taught and set apart from the circles of the academic painters. Pippin looked largely to his own memories for his inspiration, rather than outward to commonly accepted norms of art, and from this stems the freedom and strength of his images. Also, Pippin did not begin to paint until he was in his forties, so his scenes are those of an adult bringing a fully formed feeling for life to his work.

Night Call conveys perfectly the fierce, stinging onslaught of a snowstorm and the timeless, silent mystery at the bottom of the woods, which beckons from the deep perspective of the trees in the left middle ground. So powerful is the pull from that horizon that it seems to accentuate the effort of the figure crossing it at right angles. This is the country reconstructed from sense-memory, nature at its most primal and unaccountable.

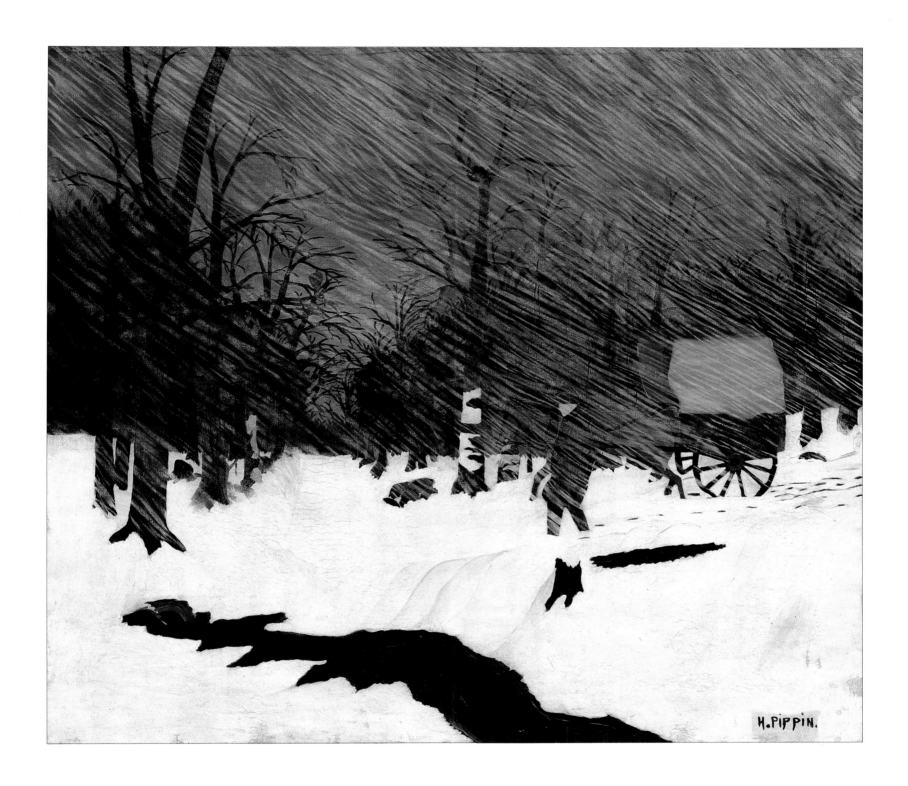

Jacob Lawrence

*Child Labor**

(Panel 24 in *The Migration, a* series of sixty works)

1940–1941

Tempera on gesso on composition board, each 12" × 18" (30 × 45cm), vertical or horizontal. The Museum of Modern Art, New York City (even numbers); The Phillips Collection, Washington, D.C. (odd numbers).

Jacob Lawrence (b. 1917) arrived in Harlem, New York City, in 1930, when he was thirteen years old. He studied art in an after-school program, knowing even then that he wanted to be an artist. With his wife, Gwen, preparing the surfaces of the panels, Lawrence finished his *Migration* series in 1941, a year after beginning it. He painted all the panels simultaneously; thus, the palette of colors visually supports the unity of the theme. Although Lawrence was born in Atlantic City, New Jersey, it is easy to imagine that the tales of children working so hard would have caused a strong emotional resonance in the young artist. There is no romanticization of the growing cycle here: beside the bright hues of the baskets, the children are all but invisible. Furthermore, the decorative patterns, like the postures of the figures and their clothing, recall Egyptian portrayals of loincloth-clad slaves, casting a chilling shadow of implication over this depiction of lifelong labor. Unlike traditional art, which sometimes requires viewers to have special knowledge in order to interpret the image, Lawrence's paintings include instructive titles that add to, rather than diminish, the complex visual power of the pictures.

* The full title of the work reads "Child labor and lack of education was one of the other reasons for people wishing to leave their homes."

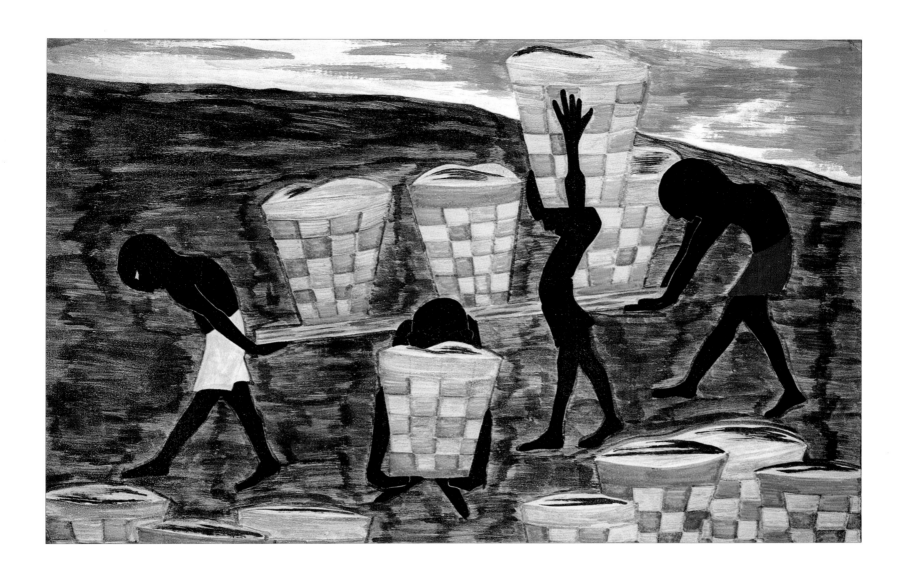

ROMARE BEARDEN

Morning of the Rooster

(from the *Mecklenburg County* series)

1980

COLLAGE ON BOARD, 18" × 13¾" (45 × 34.3CM). PRIVATE COLLECTION.

Romare Bearden (1914–1988) spent his early childhood in Charlotte, North Carolina, a community in Mecklenburg County, and even after he and his parents moved to Harlem in 1920, they summered in Charlotte with their extended family. Just as Bearden used every type of material that came to hand in his collages, so did he draw omnivorously on images of every kind, from life in Charlotte, New York, and Saint Martin to Classical Greek mythology to the paintings of Henri Matisse (1869–1954). Music was one of the most powerful influences in his life and art, and musicians, especially blues guitarists, appear in a number of his works. Here, the tilled field outside tells us this stove-warmed home is on a well-kept farm; the woman's skewed kerchief conveys perfectly the drowsy feeling of being newly awakened. We can almost hear the birds caroling outside, and the rooster's song seems to hang in the morning air.

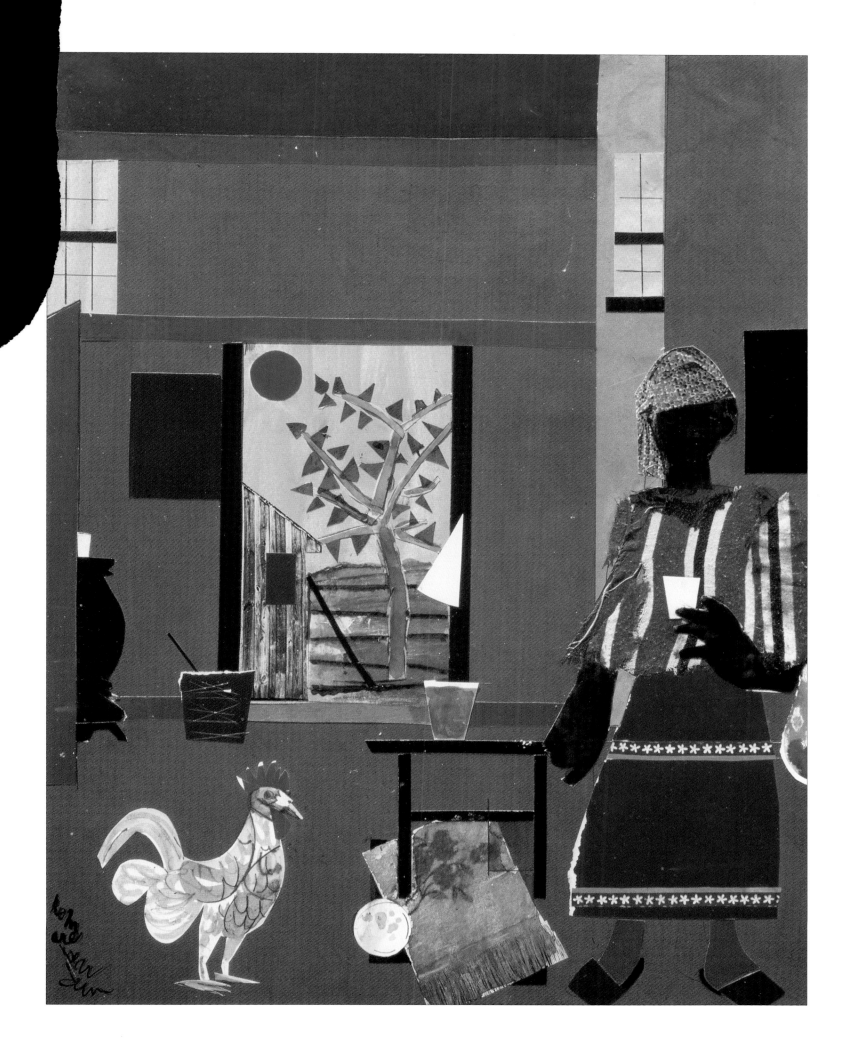

PHOTOGRAPHY CREDITS